TIM PITSIULAK

Drawings and Prints from Cape Dorset

Leslie Boyd

Pomegranate

PORTLAND, OREGON

Pomegranate Communications, Inc.
19018 NE Portal Way, Portland OR 97230
800 227 1428 www.pomegranate.com

Pomegranate Europe Ltd.
'number three', Siskin Drive
Middlemarch Business Park
Coventry CV3 4FJ, UK
+44 (0)24 7621 4461 sales@pomegranate.com

Pomegranate's mission is to invigorate, illuminate, and inspire through art.

To learn about new releases and special offers from Pomegranate, please
visit www.pomegranate.com and sign up for our email newsletter.
For all other queries, see "Contact Us" on our home page.

Front cover: *(Untitled) Polar Bear*, 2011, colored pencil and ink
Back cover: *Whales Feeding*, 2009, pencil and pencil crayon

Library of Congress Cataloging-in-Publication Data

Names: Boyd, Leslie, author.
Title: Tim Pitsiulak : drawings and prints from Cape Dorset / Leslie Boyd.
Description: Portland, Oregon : Pomegranate, [2018] | Includes index.
Identifiers: LCCN 2017042145 | ISBN 9780764981777 (hardcover : alk. paper)
Subjects: LCSH: Pitsiulak, Tim, 1967-2016--Themes, motives.
Classification: LCC N6549.P57 R96 2018 | DDC 709.2--dc23
LC record available at https://lccn.loc.gov/2017042145

Pomegranate Item No. A272

Designed by Patrice Morris

Printed in China

27 26 25 24 23 22 21 20 19 18 10 9 8 7 6 5 4 3 2 1

CONTENTS

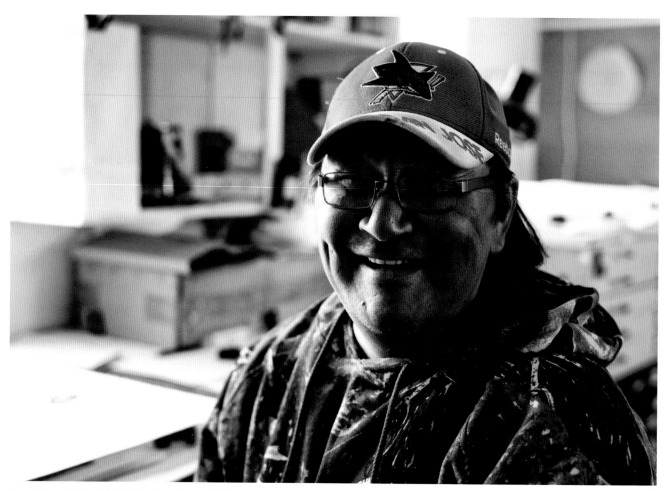

Tim Pitsiulak, Kinngait Studios, Cape Dorset, 2015
Photograph © Jason van Bruggen

ACKNOWLEDGMENTS

Many people have given generously of their time and resources to help make this book possible. In particular, I'd like to thank John Westren, Kate Vasyliw, David Hannan, and William Huffman at Dorset Fine Arts, and Patricia Feheley and her staff at Feheley Fine Arts for their wholehearted enthusiasm and support. They provided access to all of their images, files, and referrals—the substance of this project. Many others contributed their time for interviews. I'd like to thank Michael Warren, Anna Gaby-Trotz, Sarah Milroy, Scott Mullin, Robyn McCallum, Juumi Takpaungai, Mary Pitsiulak, and William Ritchie for sharing their experience and insight. It's clear from my research and these many conversations that Tim Pitsiulak touched a great many lives. I'm grateful for the opportunity to get to know him and his work so much better through this project, and I thank Thomas and Zoe Katherine Burke at Pomegranate for their continued support of Cape Dorset art and artists.

—Leslie Boyd

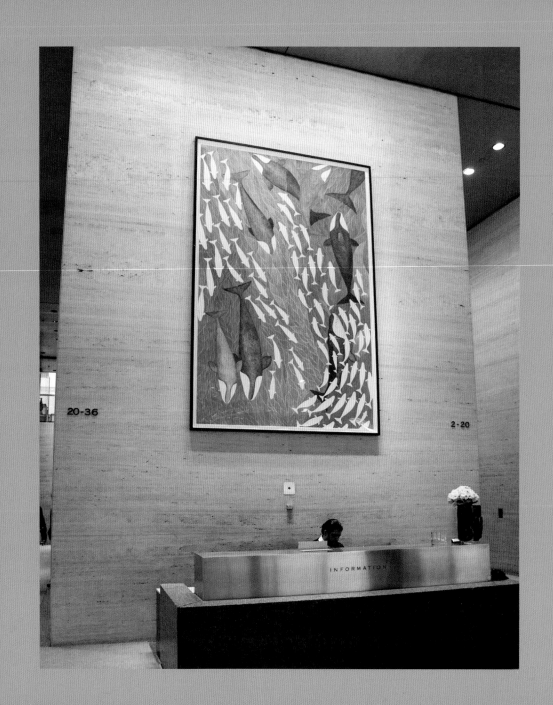

20-36

2-20

INFORMATION

TIM PITSIULAK
The Artist and the Man
By Leslie Boyd

The Toronto-Dominion Bank Tower was completed in the city's financial district in 1967, Canada's centennial year. In the same year, artist Timmuuti "Tim" Pitsiulak was born in the south Baffin Island community of Kimmirut—some 1,400 miles and worlds away from Canada's mightiest city. The building was the nation's first and tallest skyscraper—56 floors and 731 feet of black steel and glass—designed by Ludwig Mies van der Rohe, one of the most renowned architects of his time. As part of the country's centennial celebrations, the tower was hailed as a fitting monument to Toronto's growing importance as the financial hub of the country. Almost fifty years later another tribute was paid when Tim's masterwork, *Swimming with Giants*, was installed in the impressive marble and granite lobby. The work represents one of the most highly acclaimed artists of the day, a much loved man who dedicated his life's work to the expression of Inuit life and culture and sharing it with the world.

The drawing was commissioned by the building's owner, Cadillac Fairview, and was installed in 2014. At 12 x 8 feet, it is the largest drawing Tim made, featuring a pod of bowhead whales flanked by the smaller, white beluga whales that often accompany the bowhead. The water is a striking shade of turquoise blue-green, and the effect of the aerial view is of undulating waves of whales, ascending and descending through the Arctic waters: graceful, silent, and timeless.

Tim was commissioned to do the drawing in 2013 at the height of his career, which was spectacular and altogether too short, spanning only fifteen years from 2002, when he moved from Kimmirut to its neighboring community of Cape Dorset, until his death in 2016 at age 49.

At latitude 62° north, Kimmirut—formerly known as Lake Harbour—is the southernmost community on Baffin Island, four degrees south of the Arctic Circle but well above the tree line. Tiny and picturesque, the hamlet sits at the head of the long Glasgow Inlet at the mouth of the Soper Heritage River, eighteen miles from the open water of the Hudson Strait. Inuit of this region call themselves Sikusilaarmiut, which refers to the lack of ice along this coast or, more accurately, that the waters of the Hudson Strait stay open beyond the edge of the ice floe, even in winter. Sheltered by rocky hills and mountains typical of the rugged south Baffin

Swimming with Giants, 2014, pencil and colored pencil

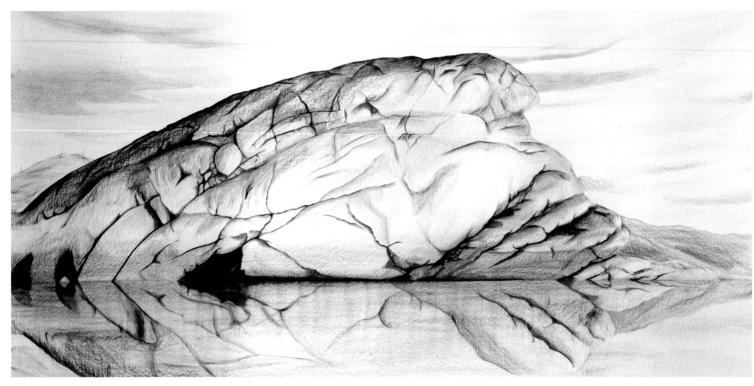

Kimmirut / The Heel, 2012, colored pencil

This is in Kimmirut, which used to be called Lake Harbour. The community is named after this hill; it means 'heel.' In the background you can see the poles. That's where one of the first RCMP posts was set up. To my knowledge those poles will be up forever, just to remind us that there was a community on the other side.

coastline, Kimmirut's protected harbor was once one of the most important in the region. The first Anglican Church mission was established here in 1909, followed by the first Hudson's Bay Company trading post in 1911.

In 1967, Kimmirut consisted of the red-roofed cluster of Hudson's Bay Company buildings, the offices and residences of the Royal Canadian Mounted Police (RCMP), a nursing station, and a small, federal day school. Inuit from the surrounding camps on the land had been relocating to the community since the 1950s, but most people still made their living by hunting and trapping, supplemented by handicrafts and the few jobs supported by the community's infrastructure.

Tim was part of a group of younger Inuit artists who grew up in the community. His was the first generation to attend regular day school, where students learned English and other rudiments of a "southern-based" curriculum designed to prepare them for the modern world. They lived in government-built houses with their extended families, listened to pop/rock music, watched television, and got around town on snowmobiles and four-wheeled all-terrain vehicles (ATVs). They shopped at the Hudson's Bay and Co-op stores, acquiring a taste for soft drinks and chips and the convenience of frozen dinners. But at the same time, "country" food (such as caribou, seal, and walrus), the land beyond the community, their own language of Inuktitut, and innumerable Inuit cultural traditions still played profound parts in their daily life and thought. These dual realities became the subject matter for this generation of Inuit artists, and perhaps for no one more so than Tim. His love of the land and the hunting lifestyle, along with his astute observation of daily life in the community, inspired him to create an outstanding body of work that would illuminate the new and true North.

Tim's life as a professional artist began as a carver when he was a teenager, and he continued carving throughout his career (pp. 10, 13). His parents, Temela and Napachie Pitsiulak, both carved to earn extra income, and Tim frequently credited them as his role models.

Tim's mother, Napachie, was originally from the Cape Dorset area and was the sister of Kenojuak Ashevak (1927–2013), Canada's most renowned and beloved Inuk artist. As Tim's career developed, he acknowledged Kenojuak as his greatest artistic inspiration. "She does amazing work," he once told Patricia Feheley, his close friend and owner of Feheley Fine Arts, his Toronto-based gallery. "She loves to draw. I feel the same way, too."[1]

Tim Pitsiulak and Kenojuak Ashevak, Feheley Fine Arts, Toronto, 2009. Photograph © Feheley Fine Arts

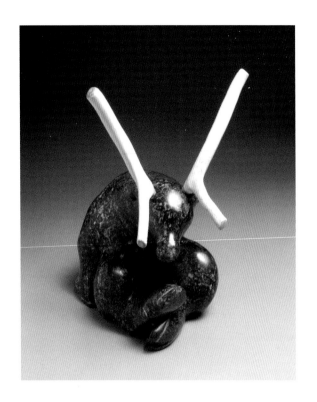

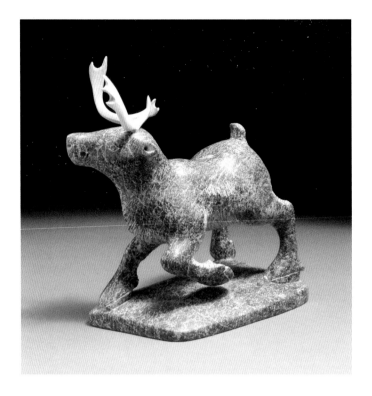

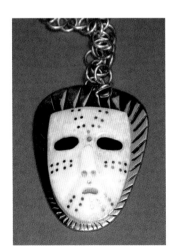

Above left: *Elderly Caribou*, 2007,
stone and caribou antler

Above right: *Rearing Young Caribou*, 2007,
stone and caribou antler

Left: *Tattooed Mask Pendant*, 2008,
ivory, silver, baleen, and silver inlay

Drawing was, without doubt, Tim's first love and ultimate creative ambition. "I grew up drawing," he told me in 2013. Upon being asked when he first started to think of himself as an artist, he said, "When we had free time in school, when we could do anything we wanted, I always picked up a pencil and paper. I always loved to draw."[2] As we talked I pictured the boy at his school desk, probably longing to be out on the land with the cold wind on his face, scanning the horizon for the caribou herds that would later reappear in his drawings. But there were few outlets for a graphic artist in Kimmirut, so Tim pursued other artistic training through Nunavut Arctic College programs, especially in jewelry and metalworking. He eventually wound up in Cape Dorset, also known as Kinngait, in 2002, seeking a fresh start as a single father with two young sons and an older daughter in tow.

Kinngait was a good place for a young man with artistic talent and ambition. It is the center of Inuit art in the Baffin, or Kikiqtaaluk, region and is home to the acclaimed Kinngait Studios. The studios have been supporting and promoting the work of Inuit artists since 1959, and Cape Dorset remains the only community in the North with a vital graphic arts and printmaking program. When Tim arrived, Jimmy Manning, also originally from Kimmirut, was managing the stonecut printmaking studio and buying drawings from local artists. Tim asked if he could bring in a drawing for review, and so began his career as a professional graphic artist.

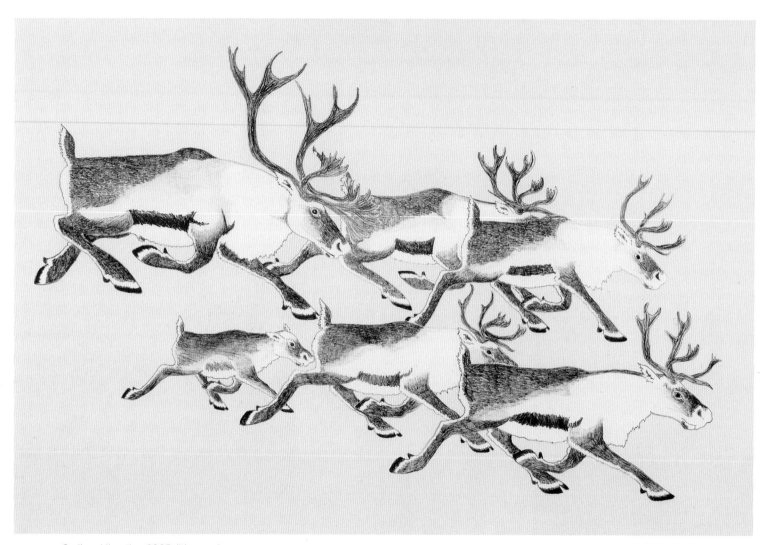

Caribou Migration, 2005, lithograph

PRINTS

The Cape Dorset annual print collection has been the foundation of the Kinngait Studios for close to sixty years. Every fall, the collection of limited print editions is released through a network of Inuit fine art galleries to collectors and enthusiasts around the world. Over the years, the collection has represented the work of four generations of local artists, such as Pitseolak Ashoona, Pudlo Pudlat, and Annie Pootoogook, and many others, whose work has brought international attention and acclaim to this faraway Inuit community of just over 1300 people.

In 2005, Tim Pitsiulak joined this illustrious group with the release of his first print, titled *Caribou Migration*. It is a straightforward image of bulls, cows, and a calf—crowded, overlapping each other, and on the move. They are beautifully drawn, with subtle shadings of gray offsetting the animals' white chests and underbellies. Akin to the work of Kananginak Pootoogook, another of Tim's artistic role models and a great Arctic naturalist, *Caribou Migration* goes beyond mere observation into a deep understanding of the ways of these animals, an understanding that can only be gained by years of close association. Not surprisingly, the limited edition of fifty prints quickly sold out.

The annual print collection did not include another print by Tim until 2008. In the interim, he continued to draw but was also engaged in metalworking with the Arctic College jewelry program operating in Cape Dorset. His second-year graduation project, *Caribou Hunt*, was a container made of copper, silver, and stone, with a finely carved, silver-antlered caribou serving as the delicate handle. On the exterior is an incised hunting scene, and inside are miniature implements forged in silver and copper, including a rifle and harpoon,

the tools of the hunter's trade. The concept, composition, and craftsmanship are superb; so impressive, in fact, that Tim was offered the job of assistant instructor in Iqaluit, Nunavut's capital city and the location of the college's main campus. But he chose to stay in Cape Dorset with his new wife, Mary, and their growing family and devote his energy full time to drawing.

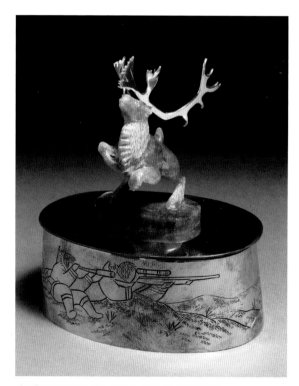

Caribou Hunt, 2007, stone, copper, and silver

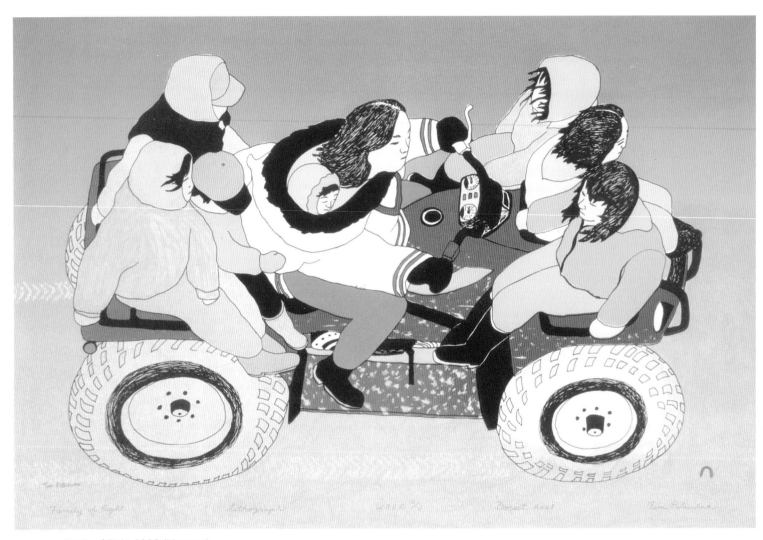

Family of Eight, 2008, lithograph

Tim's next print, *Family of Eight*, captures a familiar—albeit somewhat dangerous—community sight with Tim's unique style of affection and humor. The image initially received a tentative response from the mainstream Inuit art audience down south, who are still fairly conventional in their taste for traditional subject matter and treatment. But it took off in the growing northern market. Everyone in the North can relate to the overcrowded four-wheeled ATV flying along dirt roads in summer, stopping to let off and take on more people en route from store to home. The elevated porch of the Co-op store offers the almost bird's-eye perspective, a favorite of Tim's, and in time *Family of Eight* became one of Tim's most popular images. "I like to draw modern life," he told me, "the way we live up north. You know," he said with a laugh, "some people think we still live in igloos. There was a group of tourists here recently, and they wanted to know where the igloos were."[3] Day-to-day life in the community provided no end of artistic inspiration for Tim and a way to show the rest of the world that igloos and dog teams are no longer part of the way most Inuit really live.

Both *Caribou Migration* and *Family of Eight* are rendered in lithograph, but Tim himself was not a printmaker. That task falls to a highly skilled group of men at Kinngait Studios who have been specially trained in the complex processes involved in breaking an image down to its component parts and rebuilding it as a faithful interpretation of the original. As Tim spent more time drawing in the studio and getting to know the printmakers, he became more attuned to their

requirements and began to draw with printmaking in mind, even tackling the studios' old Vandercook press himself to try his hand at linocut.

In 2013 his interest in the technical side of image making took him to New Leaf Editions in Vancouver, British Columbia, to train with owner and master printer Peter Braune. There, he spent four weeks working with various forms of relief printing but concentrating mostly on etching. The result was a suite of etchings released as part of Kinngait's 2013 print collection.

Over the next three years, Tim's work was increasingly represented in the annual print collections, primarily his lithographs and stonecuts, mainstays of the Kinngait Studios. He also produced etching and aquatints in collaboration with Studio PM in Montreal, a longtime associate of the Cape Dorset studios. He held mainly to traditional subjects in his prints, in keeping with the modalities of the various media and the tastes of the mainstream market. By 2016, he had nine images in the annual collection—more than any other artist. In fall 2017, his work was represented in the collection for the last time, and one image in particular stands out for its graceful simplicity: a stonecut of two caribou with only their great heads and antlers visible above the waterline, as they cross the Soper River near Tim's birthplace (pp. 16–17).

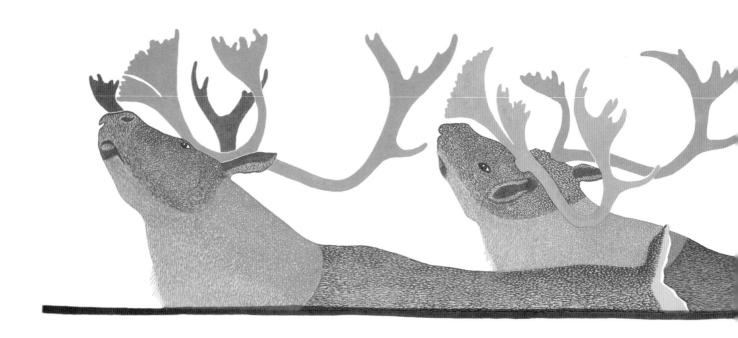

Soper River Crossing, 2017, stonecut

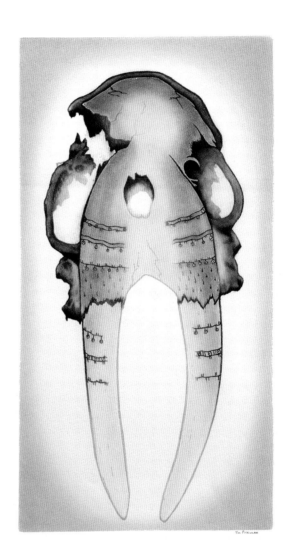

Ancient Walrus Skull, 2016, etching and aquatint

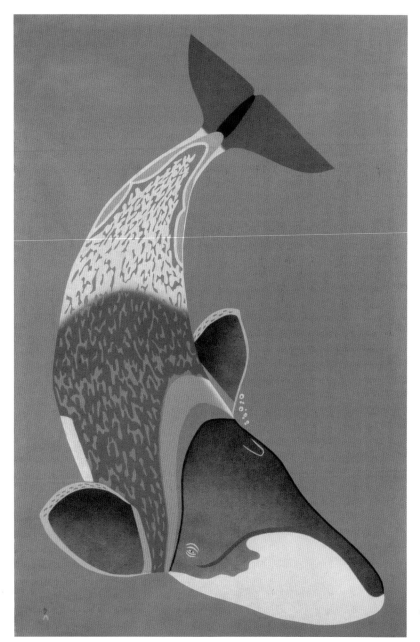

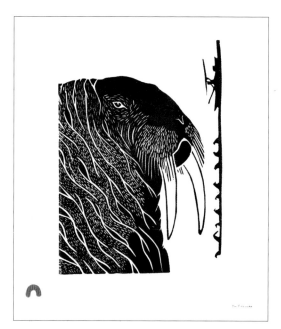

Past Hunters, 2016, linocut

Arvik Amuasijartuq (Bowhead in Amautik), 2012,
stonecut and stencil

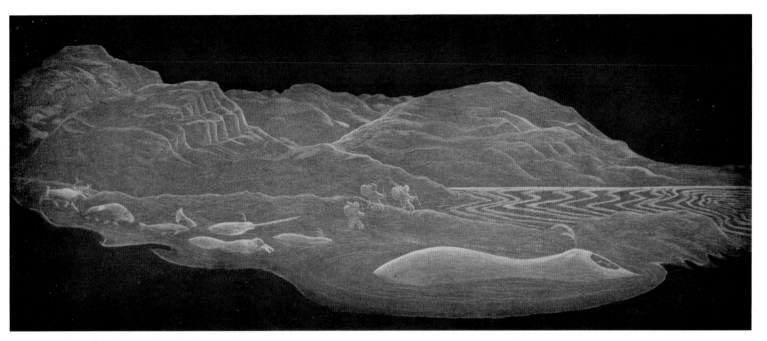

Before & After, 2013, burnished aquatint

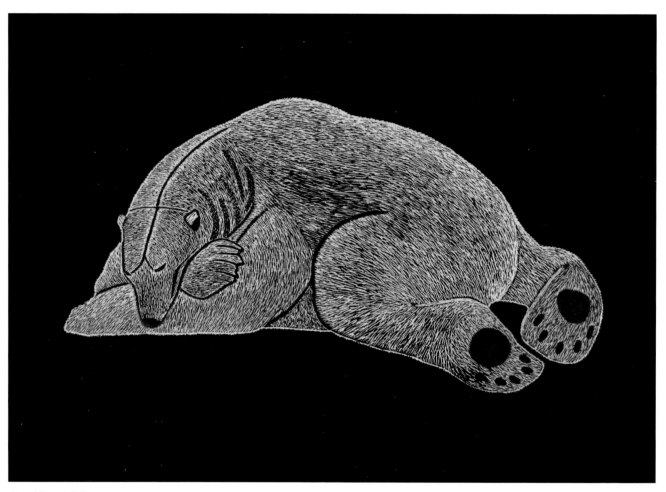

Sated Bear, 2014, stonecut

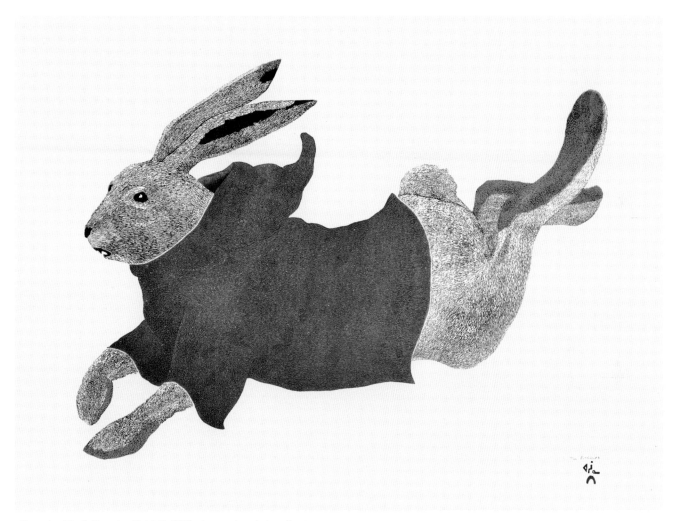

Qimaajuq Ukali (Running Rabbit), 2016, stonecut and stencil

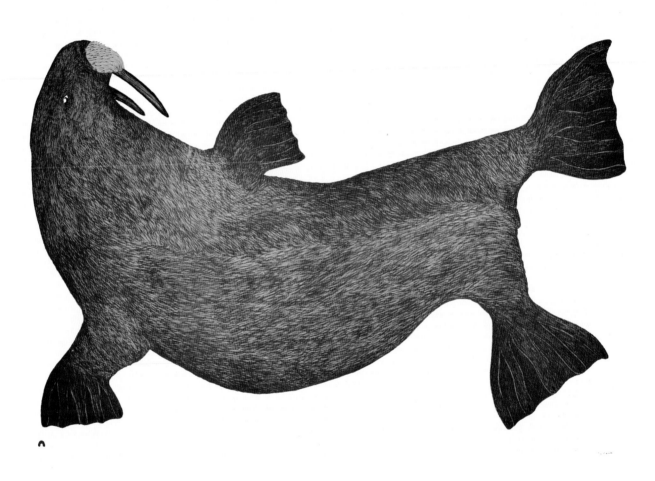

Red Walrus, 2016, lithograph

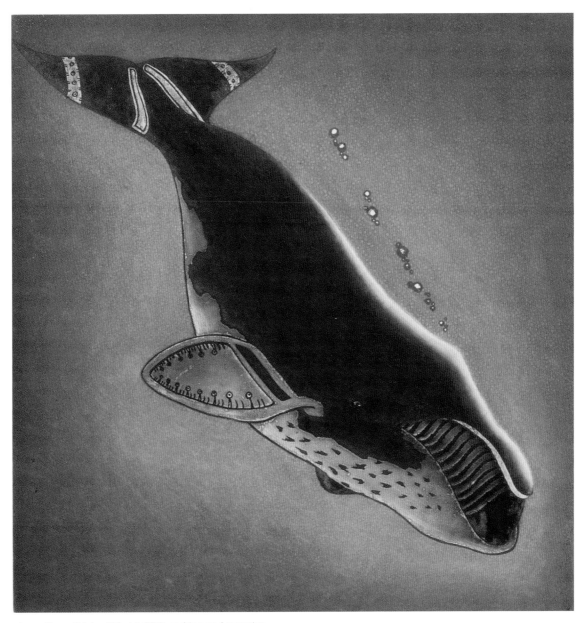

Arqavitturq (Diving Whale), 2012, etching and aquatint

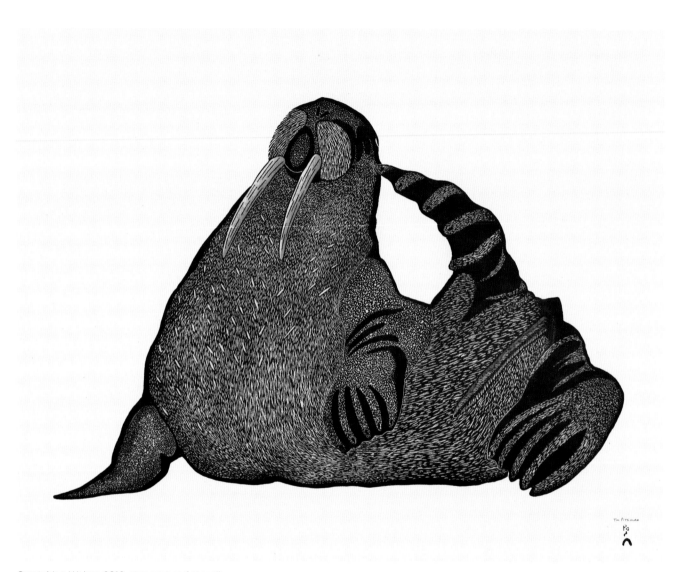

Scratching Walrus, 2016, stonecut and stencil

DRAWINGS

Tim's willingness to try new things was the cornerstone of his creativity. He liked a challenge, and his most successful work shows him extending his reach to explore new subjects, media, and techniques, and innovation in general. In Inuktitut, the relevant word is *uuturautiit*, which means to try different things. It is used to refer to the proofing process in print-making, but it can apply to any situation that calls for an experimental approach. Tim used drawing as his laboratory for research and experimentation, and he had a remarkably patient perspective on the development of his talent and creativity. Zen Buddhists call it the "beginner's mind," an atti-tude of openness and eagerness and a lack of preconceptions when learning new things. In the words of Zen Teacher Shunryu Suzuki: "In the beginner's mind there are many possibilities, but in the expert's there are few."[4] In Tim's words: "You have to be patient, like a hunter. Patience is number one. No one taught me how to draw. I learned this from myself, and I learn from every drawing I make. It's like learning from your mistakes."[5]

In 2009, the Kinngait Studios celebrated their 50th anni-versary with an exhibition called *Uuturautiit* at the National Gallery of Canada. It was a fitting title for an exhibition that included the entire inaugural, and so-called experimental, 1959 print collection, coupled with the most recent and innovative prints and drawings from the studios. Tim was represented in the exhibition by his now iconic lithograph *Family of Eight* and by his spectacular drawing of the cock-pit of the ATR 72-500 airplane. First Air, the main Baffin Island carrier, had recently added one of these impressive planes to its northern fleet, so Tim arranged to see the inte-rior and then worked from website images to recreate the cockpit with meticulous attention to detail. It is his off-angle rendering of the landscape, however, with the plane banking on approach to the short, packed-gravel runway that places the viewer right in the cockpit and takes them to the heart of the landing experience in Cape Dorset.

Tim's *Cockpit* (pp. 26–27) is almost life-size, measur-ing 4 x 8 feet. At the time, Tim was just beginning to work on drawings of this scale, prompted by longtime studio manager Bill Ritchie, who began rolling out big sheets for artists in 2004. The initiative inspired many artists to expand their horizons and tackle subjects equivalent to the size of the paper, resulting in some of the most dramatic and high-impact work ever to come out of Cape Dorset. The innovation revolutionized the look and feel of contemporary Inuit graphic art, and Tim embraced the large format with the passion of an inventor experiencing his eureka moment. From then on, no subject was too large and no challenge was too great; in fact, the bigger the better.

Herman Melville said, "To produce a mighty book, you must choose a mighty theme."[6] Tim's mightiest theme, like Melville's, was a great whale, and the bowhead was a wellspring of inspiration for him; he drew them diving and sounding, solo and in pods. Among the largest and longest-lived animals on earth, whales are imbued with mystery and mythological significance in cultures around the world, worshipped in some and feared in others. For Tim, they were part of his natural world, and he would frequently sight them while out hunting. But they were also a connection to

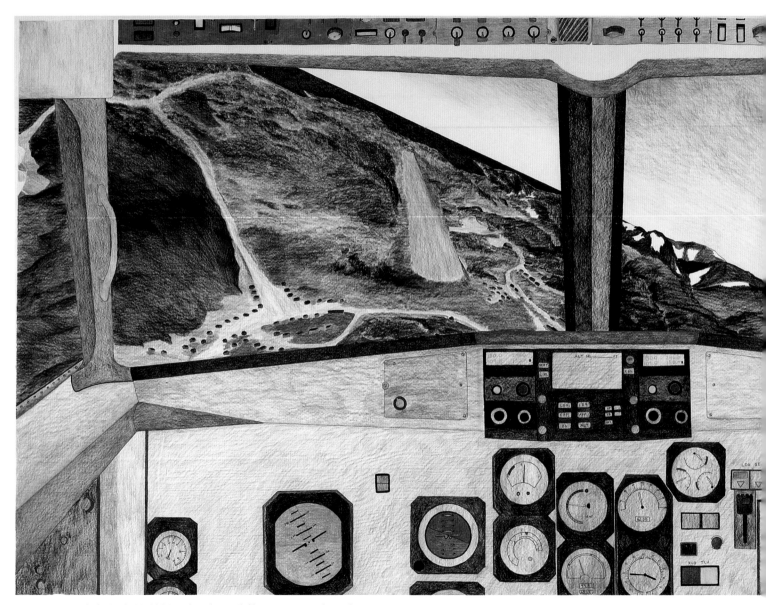

Untitled (Cockpit), 2008, colored pencil, fiber-tip pen, and graphite

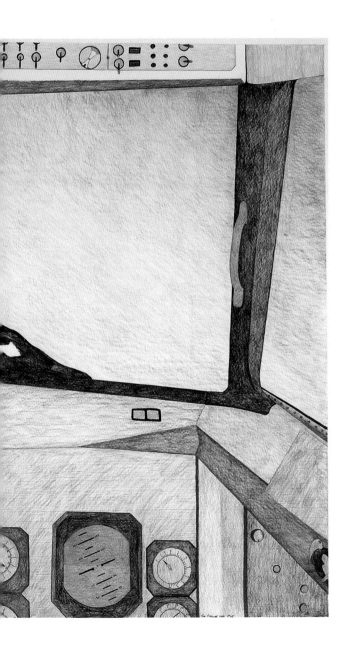

another world and another time—the great whale hunts of the last century when his Thule ancestors pursued the beasts in *umiaks*, or sealskin boats, with only handmade harpoons. Tim illustrated this connection by including motifs of Thule artifacts: the shaman's mask carved in ivory, snow goggles, ivory hair combs, as well as tattoos and other decorations, all adorning the body of the whale as they would have his Thule ancestors. The finished works (pp. 23, 29, 57, 67) show Tim at his most imaginative and lyrical, telling the story within the story of the bowhead whale. These dynamic images are also homages to his Thule and Dorset cultural forebears for their accomplishments and their survival. As Michael Warren of the Madrona Gallery in Victoria, British Columbia, observed during our talk about the broad appeal of Tim's work, "These are universal themes, and perhaps there is something in all of our souls that bears an inherent appreciation of these qualities."[7]

If Tim wasn't actually out on the land doing his work of hunting and harvesting, he was thinking about it and working its beauty and bounty into his art. He referred to the land as his "office," perhaps a friendly jab at the southern preoccupation with busy lives in enclosed spaces. More likely, the expression was a nod to hockey legend Wayne Gretzky, who became known for setting up behind his opponent's net, until the area was nicknamed "Gretzky's office." Like many Canadians, Tim was a huge hockey fan, and for him the land was the place where he felt most comfortable, most capable, and most himself.

Tim was known in the community as a great hunter. He honed his skills and gained the ancient hunting survival knowledge in the traditional way from his father, who would regularly take him out of school so he could learn to hunt. In

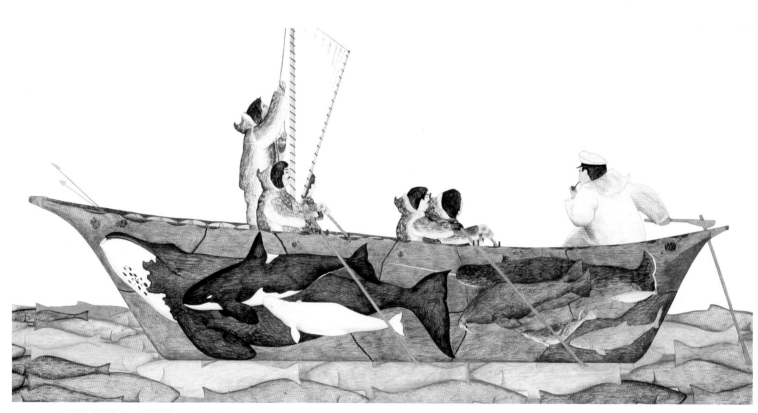

Untitled (Whalers), 2009, pencil and pencil crayon

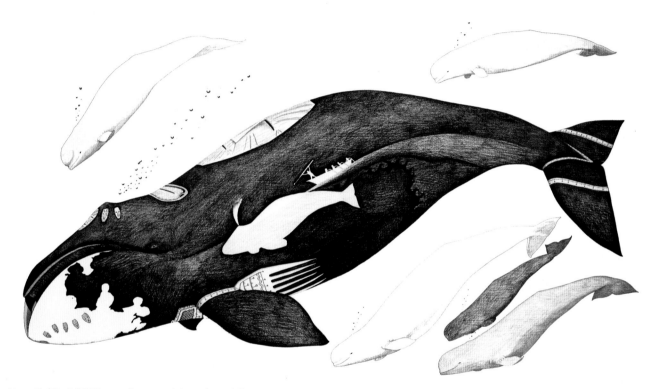

From the Past, 2008, pencil crayon, ink, and graphite

I enjoyed doing this drawing very much. From what I have learned from the past, the Thule made good use of the bones of the bowhead, so I thought I would put some things onto the whale that related to the Thule. On this one I put masks, goggles, an ivory comb, and tattoos and decorations—all things that the Thule made. Last year I saw a lot of bowhead around Cape Dorset, so the lower jaw part is the coastline around Cape Dorset. The little masks indicate where the Dorset people lived in their qummuks, *or sod houses.*

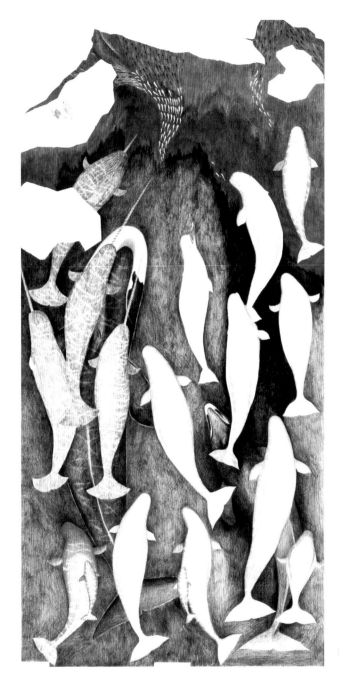

This is at the floe edge. In the background you'll see a bowhead and calf. The beluga and narwhales are swimming with the bowhead. The fish in front are Pacific cod, and the narwhales are feeding on them.

Whales Feeding, 2009,
pencil and pencil crayon

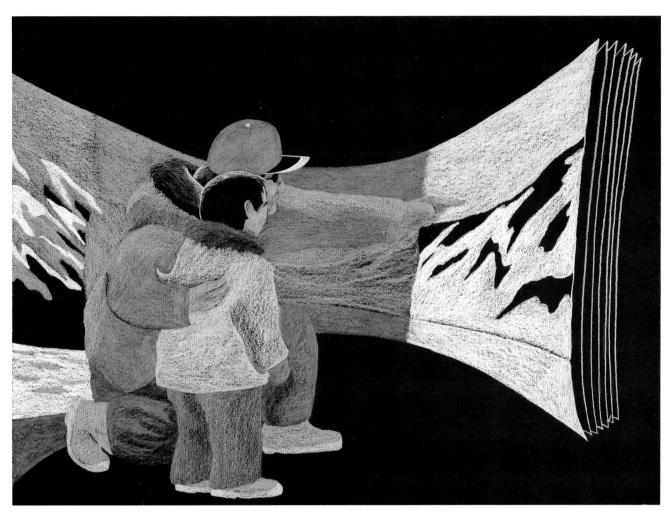

Passing On Tradition, 2012, colored pencil

keeping with Inuit traditions of learning from more experienced elders, Tim also believed it was his responsibility to pass his knowledge and expertise on to the next generation. In 2013 I asked him if he thought Inuit connection to the land was being lost as the community continued to change and adopt more "southern" ways. He told me that it wasn't close to being lost in Cape Dorset. "My father passed the tradition to me, and I am passing it to my boys, and to my daughter as well, who comes along on family trips. Hunting is as important to them as it is to me."[8]

Tim also believed that it was the responsibility of a successful hunter to share his catch with the community. In traditional Inuit custom, sharing ensured the survival of the camp, and the practice still applies to the present-day community. Tim took great pride in his success as a hunter and his ability to share, first with his fellow hunters and their families and then with anyone in the community who wanted country food. "With the last two walrus I caught, I made the announcement on the local radio, and they were gone in ten minutes; that's all it takes. People have their own styles," he told me. "With me it's first come, first served, but some people have seal meat parties. Overall, it all comes down to sharing."[9]

Tim's generosity extended to outsiders, too. He was fond of taking visitors and friends from the south out on the water to point out the old traditional campsites and show them how to spot seals coming up for air or how to check the beluga nets. Anna Gaby-Trotz of Open Studio in Toronto described her day trip in Tim's freighter canoe as life altering—and also the coldest she'd ever been! Despite her brush with frostbite, the experience deepened their already close friendship formed during Tim's two-week printmaking residency at Open Studio. At the heart of Tim's artistic mission was a genuine hospitality, an open invitation to his southern audience to step outside of their world and take some time to get to know his. "What more can I ask for?" was his frequent refrain. "That's the best thing about being an artist and a hunter, the reward that comes. What more can I ask for than that people are noticing what we have up here?"[10]

〰

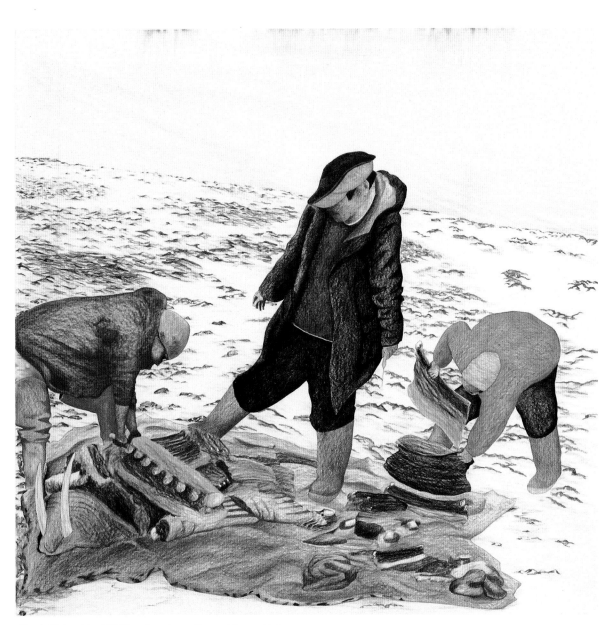

Fresh Walrus Meat, 2010, colored pencil, graphite, and ink

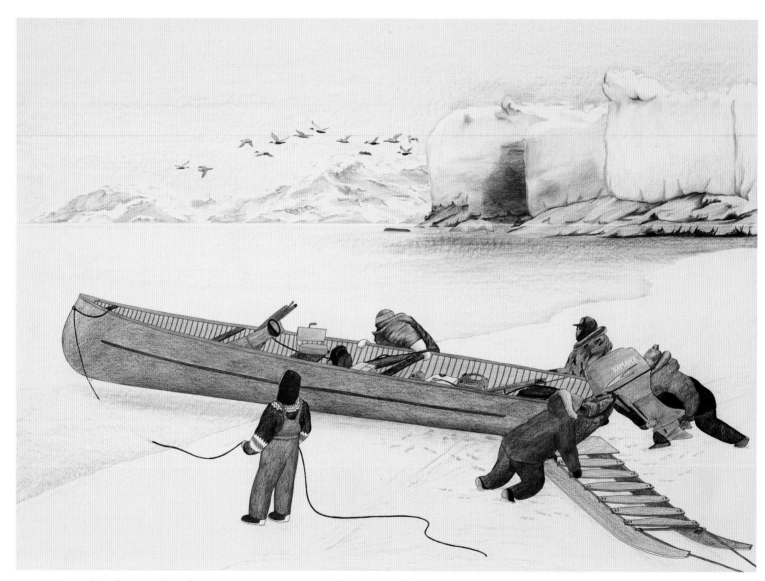

Launching Canoe at Floe Edge, 2012, colored pencil, graphite, and fiber-tip pen

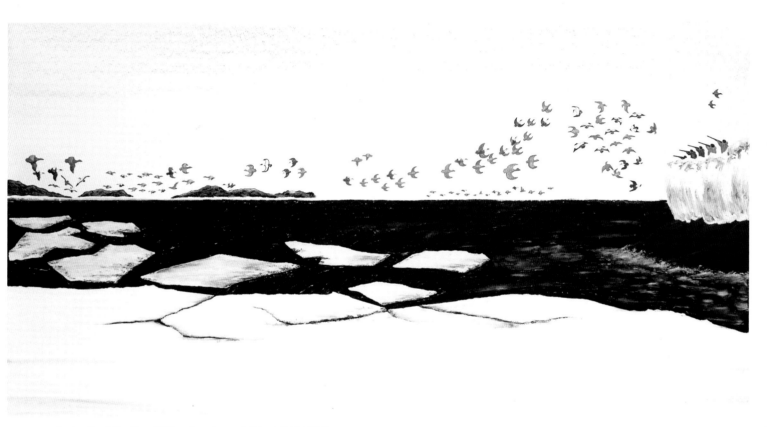

Spring Duck Hunting, 2013, colored pencil, ink, and oil pastel

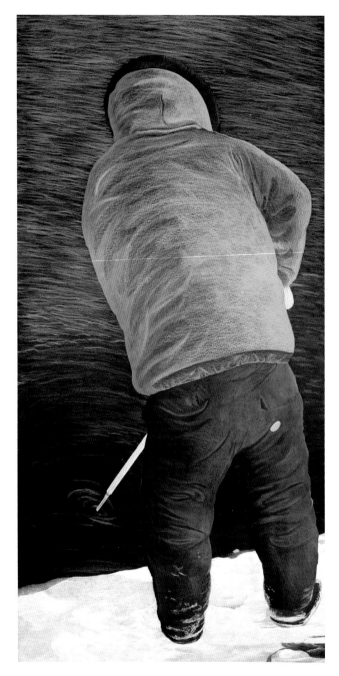

This drawing is very special to me. This is my cousin, gathering seaweed last spring. My best joy of life is hunting. I have always loved hunting with him, as we are relaxed in a world of our own.

Gathering Seaweed, 2013, colored pencil

Nuvukallak, 2012, colored pencil

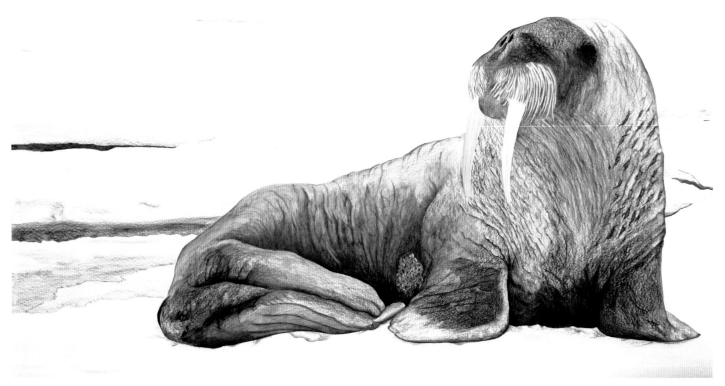

Old Walrus, 2013, colored pencil

You'll see a pressure crack in the ice, and that's where it emerged from the water. As soon as the word was out, I went out on my snowmobile—took my camera and rifle, of course, in case there was a polar bear. But all I did was take pictures of this walrus. In the folds of his skin are Thule masks, and oysters behind the front flipper, because the walrus eats oysters and clams back home.

Aupaluktu Sunrise, 2012, colored pencil

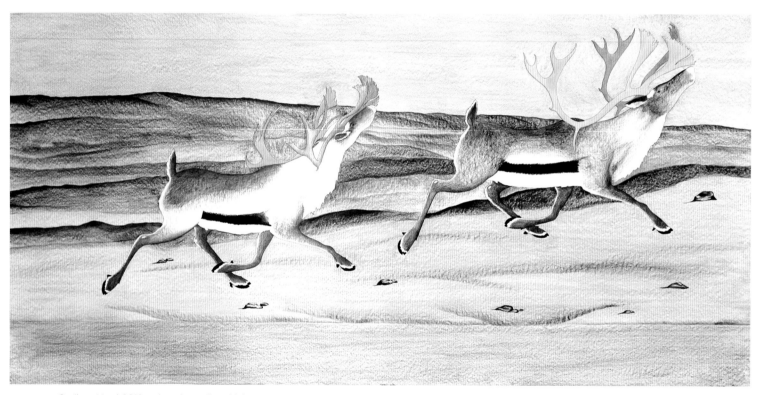

Caribou Herd, 2012, colored pencil and ink

I love to draw caribou. In this case I wanted to add the color we get in the late summer and fall. In the south the trees turn color, but up here it is the tundra that turns color.

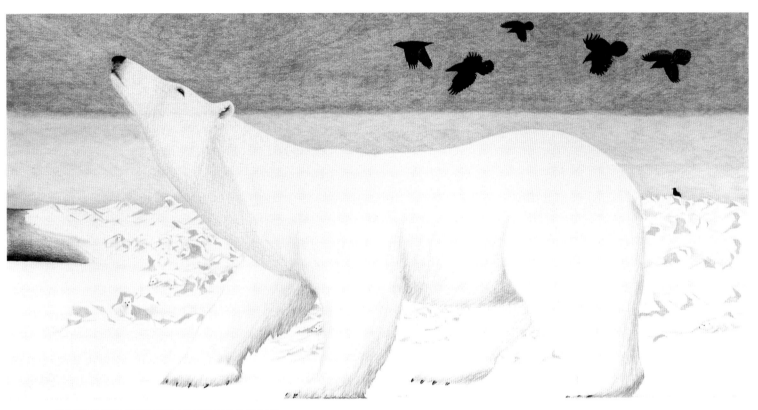

(Untitled) Polar Bear, 2011, colored pencil and ink

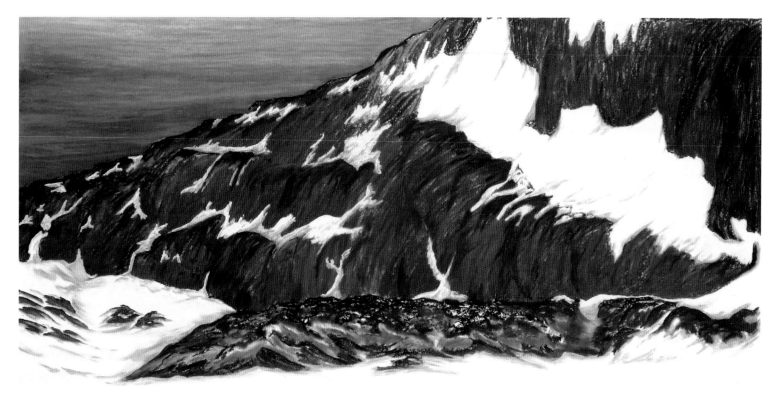

Spring Landscape, 2011, oil stick

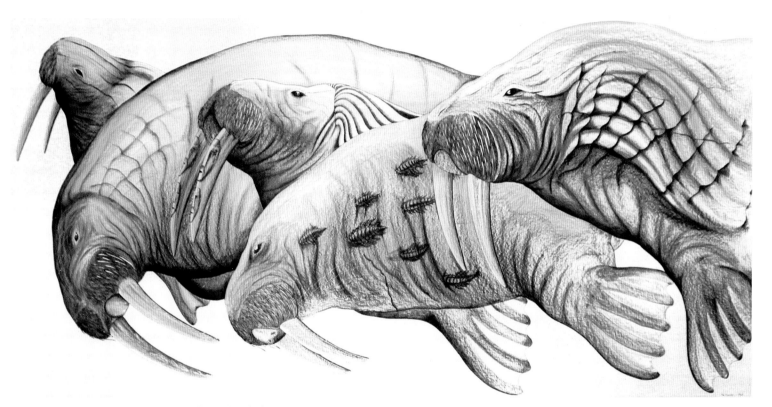

Migrating Walrus, 2012, colored pencil and ink

This one is badass! It shows the power, the strength of the walrus, caught like ivory with the Thule marks. It is one of my favorite drawings. I dulled the point of an etching stylus and created white lines on the paper before I colored it. You won't see that style anywhere; it's something I wanted to try, and it turned out very well. I was fascinated by the work of the Thule culture. They didn't have power tools; they didn't exist when that mask was made.

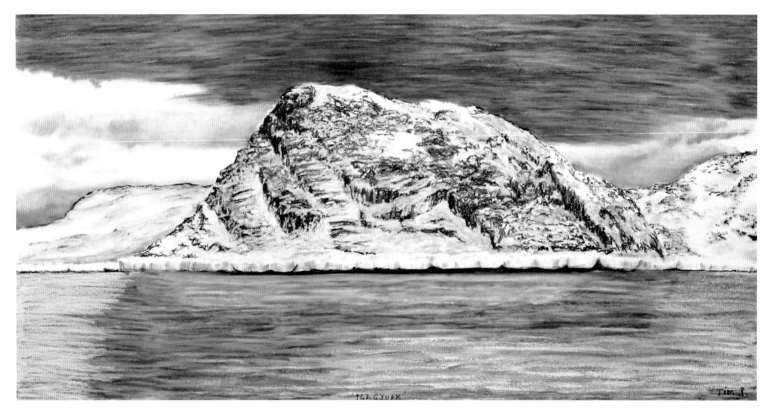

Igaqjuak, 2011, oil stick

EXHIBITIONS

Tim's first solo exhibition was in 2009 at Feheley Fine Arts in Toronto. True to his desire to show people how Inuit really live, the exhibition presented images of the North that had never been seen before: massive front-end loaders and backhoes, garbage trucks and container ships, writ large and drawn with the eye of a photographer and the skill of an accomplished draughtsman. Tim took his camera everywhere he went—around the community, out on the land, and up in the plane—shooting everything that caught his attention. Later he'd print the images he liked and use them as reference for his drawings. His finished works combine the best of both media: the precise realism of the lens diffused through the pencils, fiber-tip pens, and oil sticks that he used with great care to create texture and nuance. "Visual dynamite!" exclaimed curator and art critic Sarah Milroy when she first saw these drawings on a 2012 visit to Cape Dorset. In "The Hunter Artist" profile written for *The Walrus*, she added that in these images of the North, Tim was "carrying the charge of the new and novel."[11] For Tim, they represented the machinery of modern life, as well as the essential and ever-present heft and hum of his rapidly growing community.

Tim had five solo exhibitions at Feheley Fine Arts between 2009 and 2017, and galleries across the country exhibited his prints as part of the annual Cape Dorset print collection. The picture of Tim that emerges is of an artist who never stopped challenging himself, constantly expanding his range

Tim Pitsiulak, Feheley Fine Arts, Toronto, 2009
Photographs © Feheley Fine Arts

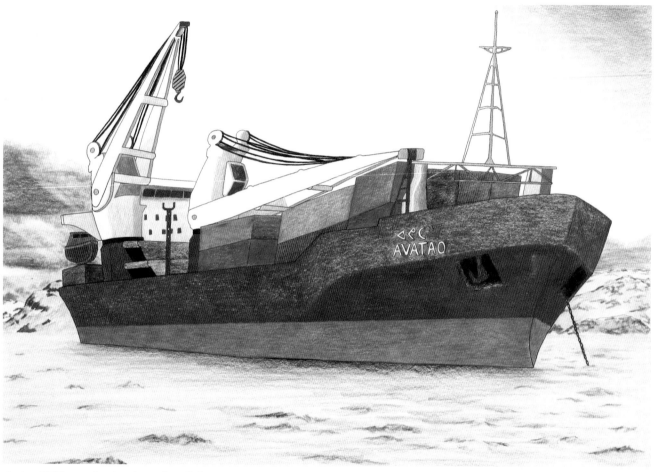

Avataq, 2008, pencil, colored pencil, and ink

The Avataq *is the annual sealift that*
comes in the summer or fall.

Note: The name refers to the sealskin float formerly
used by Inuit to keep the harpoon from sinking.

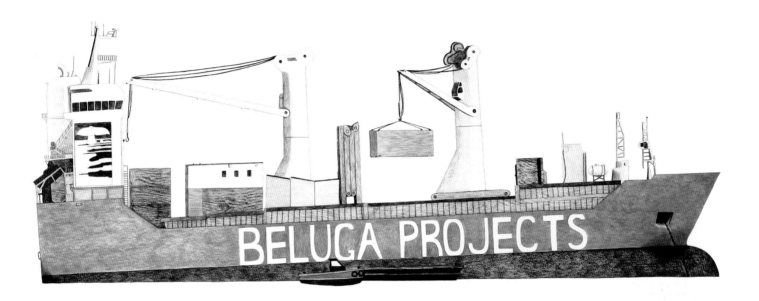

Beluga Projects, 2009, colored pencil and ink

I found this ship interesting because of the name. Bill [Ritchie] and I looked it up and found that it was an international ship; it went overseas.

Note: Beluga Projects is a German company specializing in heavy-lift shipping.

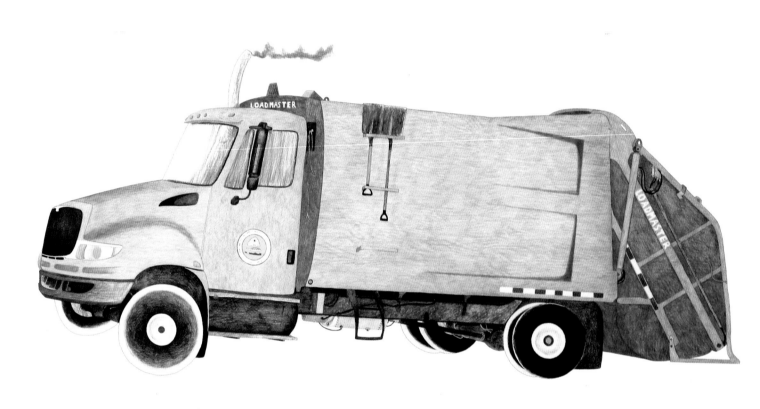

Loadmaster, 2008, pencil crayon and ink

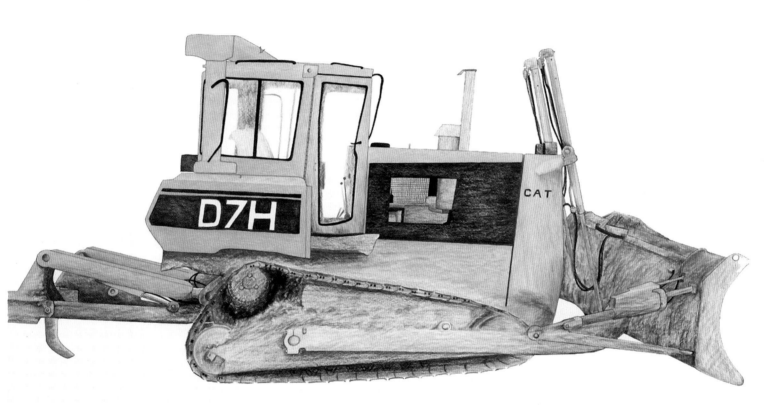

D7H Bulldozer, 2010, pencil crayon, pencil, and ink

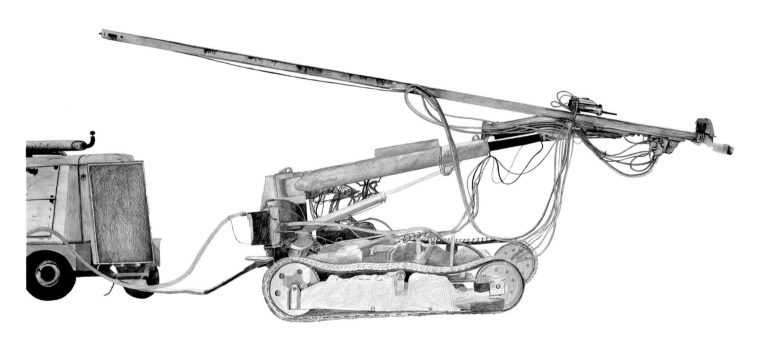

Canadrill, 2015, colored pencil and ink

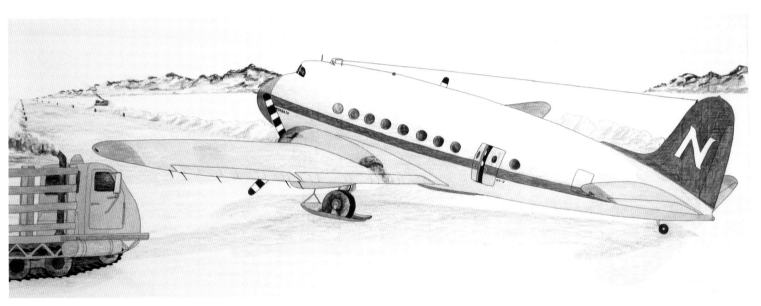

(Untitled) Nordair DC3, 2009, pencil crayon and ink

Before they built the gravel runway, the bulldozers would make the landing strip on the sea ice and mark it with barrels. The track vehicles were the first big vehicles I saw. I remember whenever a DC3 would come in, all the kids would run down to the ice.

of subjects, media, technique, and technology. He began working on black paper, a backdrop he particularly liked, using the paper to create silhouettes in negative space and adapting his palette to rich reds and ochers. The drawings have a completely different look and feel from his earlier work, now with atmospheric, moonlit landscapes with hunters patiently waiting for the herds of grazing caribou, and the great bowhead rendered in the patina of aged ivory, gold and glowing in the deep, black water (p. 57).

Tim also expanded his themes during this time, venturing into Inuit mythology and folklore with playful pictures of animals dressed in parkas (p. 61) and *amauti*, the women's parka designed for carrying a baby in the pouch on the back. He dipped into the realm of the supernatural, showing the shaman transforming from human to animal spirit and struggling to release himself again (p. 60). These drawings are packed with power and fierce energy, qualities that Tim strove for and attained in his favorite finished works.

Whether working with traditional or contemporary themes, Tim was full of surprises, especially when he brought the two into close contact. In 2014 he purchased a GoPro HERO4, a waterproof video and still camera that he suspended from a line into water to capture the sights and sounds of his maritime world. Tim's drawings (pp. 64–65) show this tiny device dangling in a rainbow of seaweed or floating amid whales and seals as part of his endlessly curious quest to see, hear, and capture every element of his surroundings. The only piece of cutting-edge technology that he didn't own but wished he did, was a drone.

Tim was an artist perfectly in tune with his environment and his time, a period of increased attention on the North and its past, present, and—many believe—its uncertain future.

In 2013, Canada celebrated the 100th anniversary of the Canadian Arctic Expedition, a scientific expedition in the Arctic Circle between 1913 and 1918, organized and led by anthropologist and explorer Vilhjalmur Stefansson. Tim was commissioned by the Royal Canadian Mint to create a composition for a commemorative coin titled "Life in the North" (p. 66). Working within the very small scale of a twenty-five-cent coin, Tim's thoughtful execution incorporated traditional, symbolic motifs with the beautiful, adorned bowhead at the center. Inuit in kayaks in pursuit of the great whale wrap around the perimeter of the coin, and the ivory comb lying across the head of the bowhead suggests the

Tim Pitsiulak in Cape Dorset, 2011
Photograph © Patricia Feheley

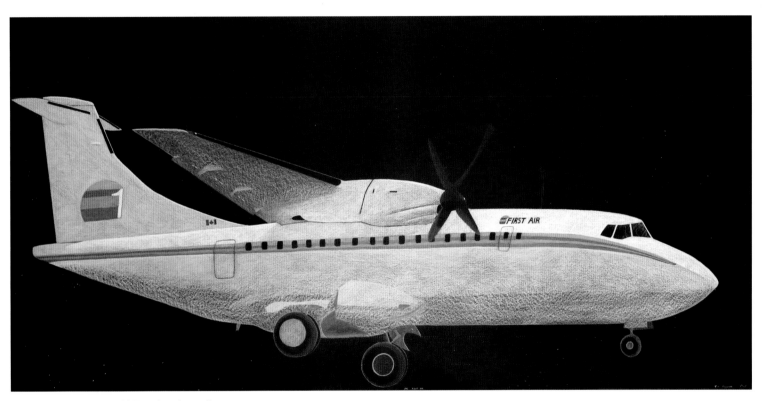

ATR First Air, 2015, colored pencil

Caribou Chase, 2011, colored pencil

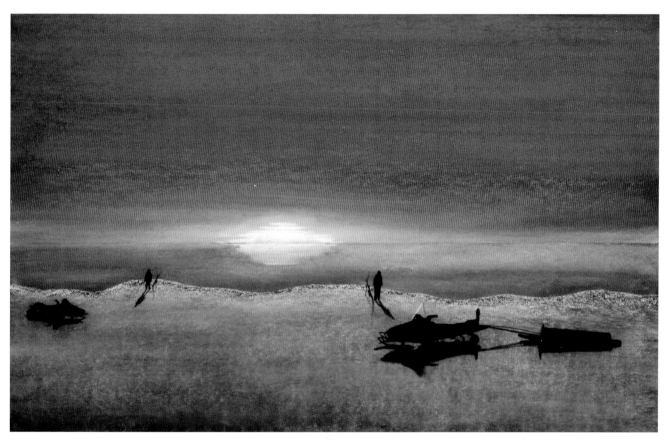

Morning Commute, 2015, pastel

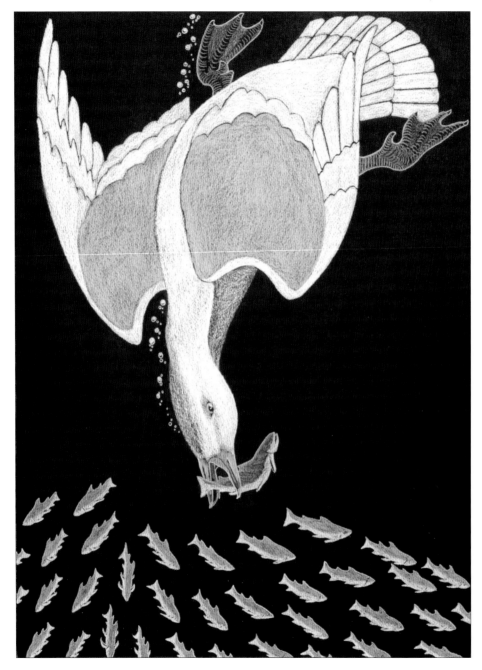

Nose Dive, 2014, pencil, pencil crayon, and ink

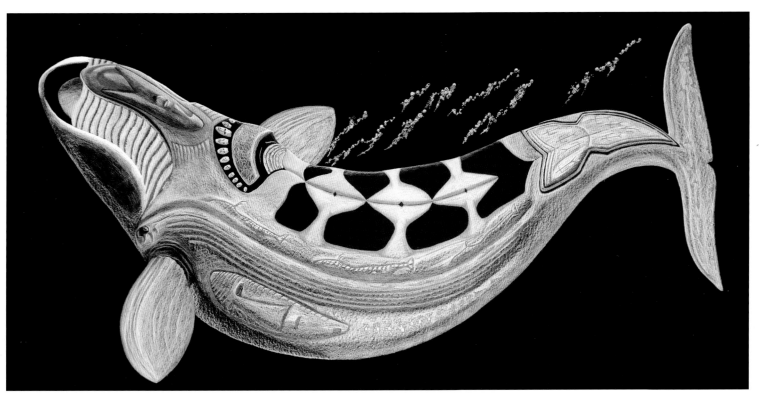

Ivory Aqvik, 2013, colored pencil

This is a bowhead whale. I wanted to draw it with ivory colors since our ancestors, the Thule, made ivory images. The mask on the belly is from that time, and you can see people traveling on foot—no snowmobiles. I do these images because I respect them so much.

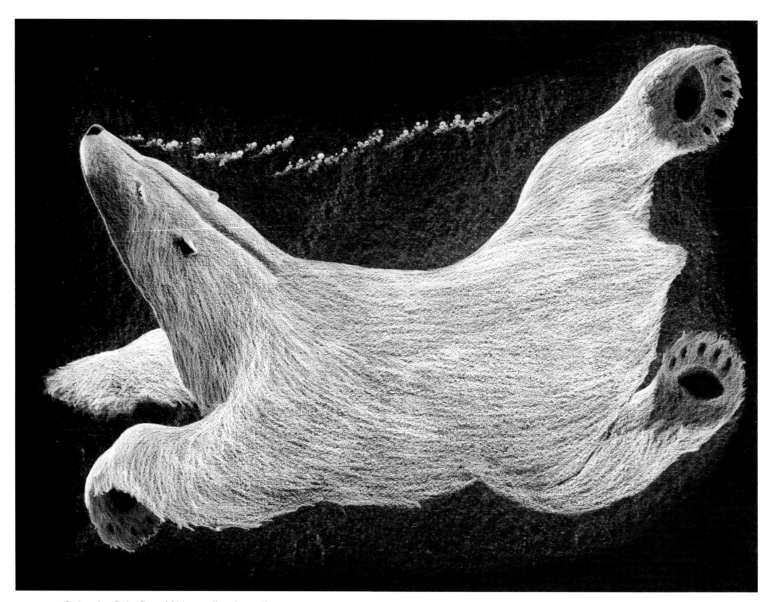

Swimming Polar Bear, 2014, pencil and pencil crayon

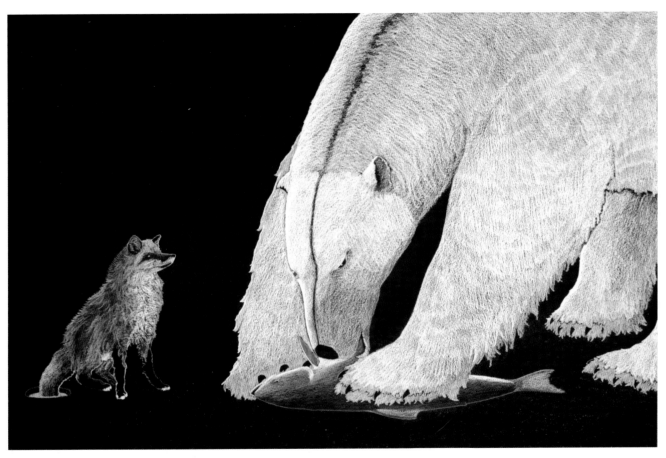

Red Fox Return, 2014, colored pencil

Fox often follow polar bears to eat the scraps the bears leave
behind. But there is an old story of a fox who was able to catch
fish through a hole in the ice with his tail. In this case the fox is
helping the bear to eat in the winter. They are best buddies.

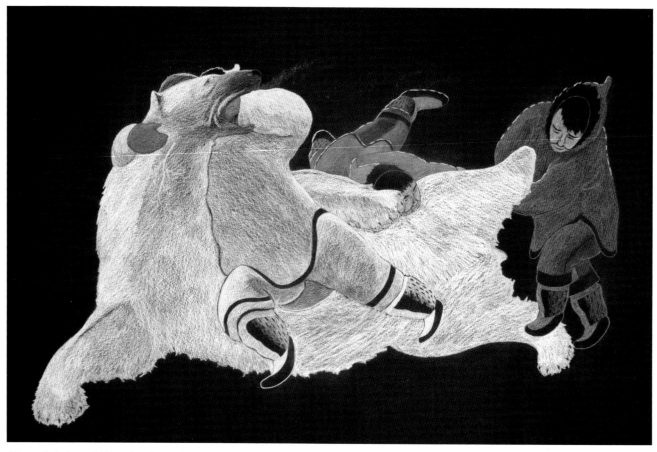

Shaman's Release, 2014, colored pencil

The shaman has turned into a bear. The others
are trying to help him get out of his bear skin.

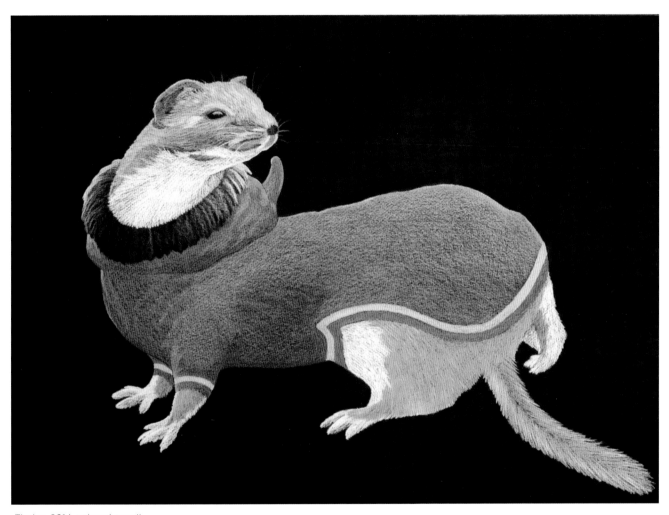

Tirgiaq, 2014, colored pencil

This parka series of drawings shows a weasel in its summer phase. In the winter, they are white.

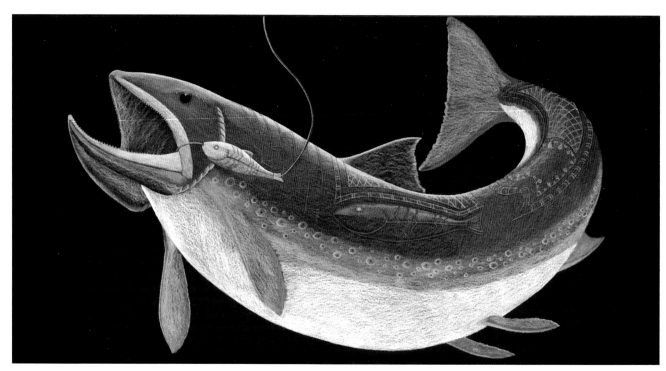

Ivory Cast, 2014, colored pencil

[Uutuit (Sunbathing Walrus)] took two weeks to complete. On one of my hunting trips I saw the walruses herding down a beach side. This is from a picture that I took but I didn't realize at the time that I'd captured a very beautiful image—only when I got home, because it's too cold to scroll through your camera.

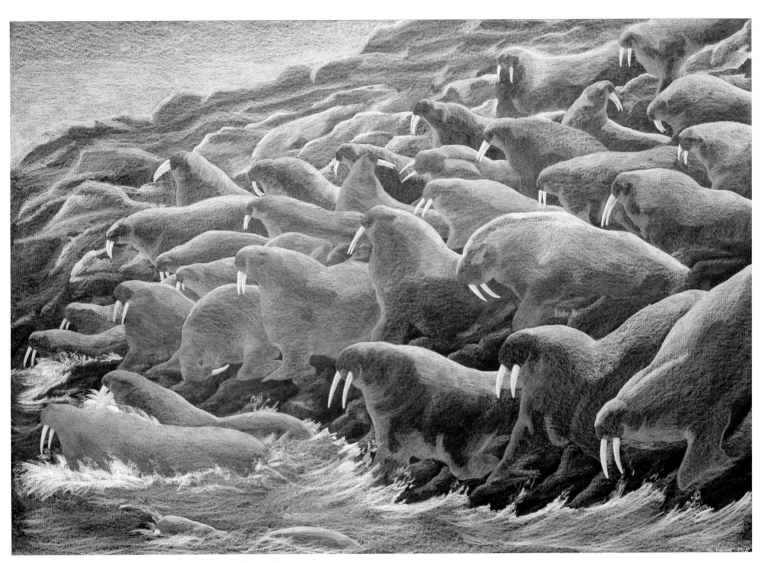

Uutuit (Sunbathing Walrus), 2012, colored pencil

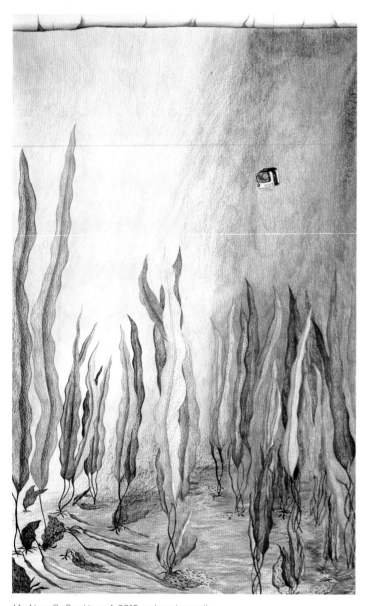

My New GoPro Hero 4, 2015, colored pencil

This one is purely imaginary. Bill [Ritchie] and I had been talking about drones, and I imagined an aerial view of an iceberg. I wish I had a drone.

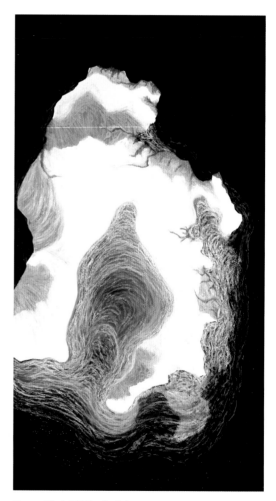

Drone Shot, 2016, oil stick

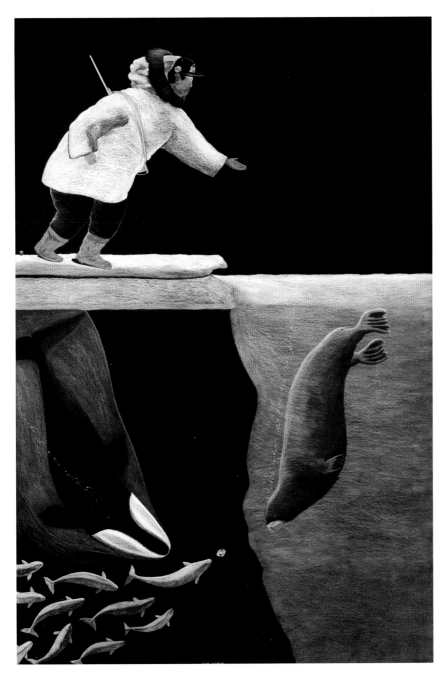

GoPro Hydrophone, 2016, pastel

story of Inuit expansion across Canada, from their first crossing of the Bering Strait.[12] Tim's bowhead will make its final appearance at the new Canadian High Arctic Research Station, opened in Cambridge Bay in late 2017. As the headquarters of Polar Knowledge Canada (POLAR), the station will work at the global cutting edge of science and technology in the North. Tim was awarded one of the design commissions, with his signature bowhead to be incorporated in the building's floor tiles. It is a fitting assignment and tribute to a man and artist so intrigued by technology and so engaged in his land's history, and—he would certainly argue—its enduring and promising future.

Tim's last trip to Toronto was in spring 2016 to attend a residency at Open Studio, Canada's leading printmaking center. With technical director Anna Gaby-Trotz and master printer Nick Shick, Tim worked on two screenprint editions from drawings created on-site (pp. 68–69; published posthumously as a special release in the spring of 2017). Tim had never worked in screen printing before but was undaunted by the process, completing two large drawings in two weeks with no preliminary sketches or composition grids, and then separating out the colors and drawing each layer again. Every day he would arrive at the studio before opening hours and work solidly until the end of the day, making time for the steady stream of visitors, artist talks, and workshops that packed the heady two weeks. Shick described Tim's disciplined work ethic as astonishing but recalled that there was always time for teasing, joking, and short breaks to check in with Facebook friends in the North and share the stream of pictures and social media chatter with studio staff. Even when he learned that he had lost his canoe in the spring ice breakup, Tim stuck with the work at hand. But two weeks was Tim's maximum; he never wanted to be away from home and family for longer.

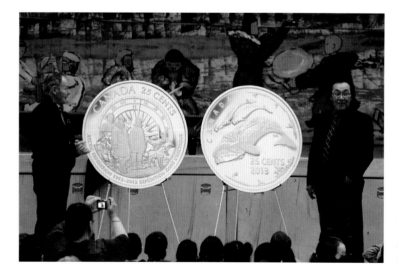

Tim Pitsiulak (at right)
"Life in the North" commemorative
coin unveiling, Ottawa, Ontario, 2013
Photograph © Royal Canadian Mint

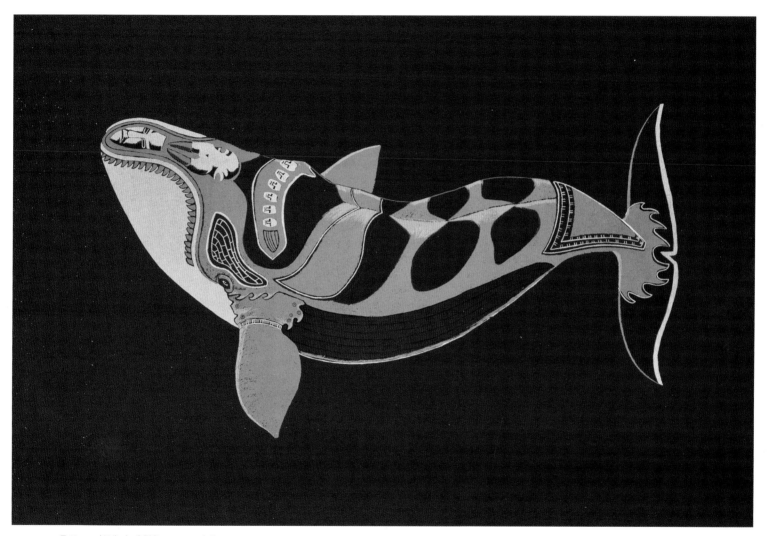

Tattooed Whale, 2016, screenprint

Tim Pitsiulak and *Swimming Bear* (in process),
at Open Studio, Toronto, 2016

Photographs © Cheryl Rondeau

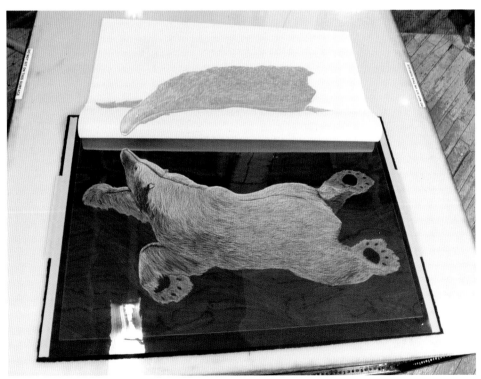

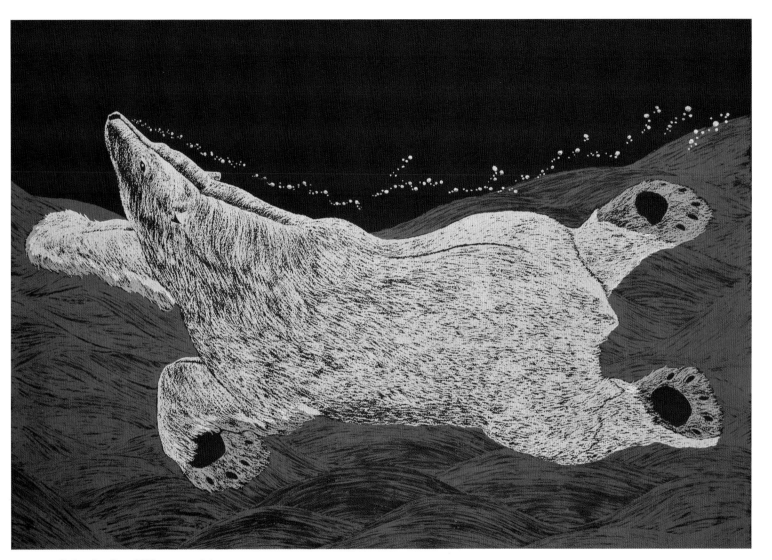

Swimming Bear, 2016, screenprint

Tim's drive was a hallmark of his success, and he returned to Cape Dorset with work to do. A prolific artist earning top dollar at the height of his career, he was able to buy a new canoe and equipment to put his hunting life back on track for the coming summer. Summer is a short season in the North, and the lure of the land often takes precedence over everything else. Drawings and carvings are still purchased, but the printmaking studios are closed for the season, allowing artists and staff to take full advantage of the warmer temperatures and open water. This is also the season when passages to the High Arctic open up. Earlier in his career, Tim was invited to observe the POLAR-sponsored research expedition to gather data on ice conditions, a flashpoint for scientists studying the effects of global climate change. His drawings capture the whole busy scene: the team of researchers cutting through the sea ice; the thrum of the helicopter transferring ice samples to the waiting icebreaker, and a diver in the foreground going under the ice to take samples and pictures never seen before (p. 73). The expedition was a natural for Tim's inquiring mind and documentary sensibilities, and it led to his broader exploration of the beautiful, powerful, primordial world of ice. These drawings were the focal point of *Ice*, his last exhibition in Toronto, timed to coincide with Art Toronto, the city's international art fair.

Although Tim was unable to attend his last exhibition, his presence at his previous exhibition openings—attended by artists, curators, collectors, family, and friends—made them occasions for crowded celebration. At the center of it all, Tim spoke directly and eloquently about his work, explaining his subjects, his approach, his techniques, and his materials. His great joy in the creative process and in his community and culture shone through his commentary as he told stories, cracked jokes, and raised his glass in gratitude for the opportunity to see his work framed and looking magnificent on the gallery walls. Tim realized he was becoming a highly acclaimed artist, and though he delighted in his artistic achievements he seemed never to think of himself as a celebrity. And neither did anyone else. One of Tim's great gifts was his essential humanity. His kindness, his spirit of fraternity, and his wry sense of humor drew people to him, and he made fast friends wherever he went. As Scott Mullin, a former vice-president of the Toronto-Dominion Bank remarked: "He was a calm, solid, lovely man. He seemed as comfortable on the 54th floor of the TD Bank Tower as he would have been in his own home."[13]

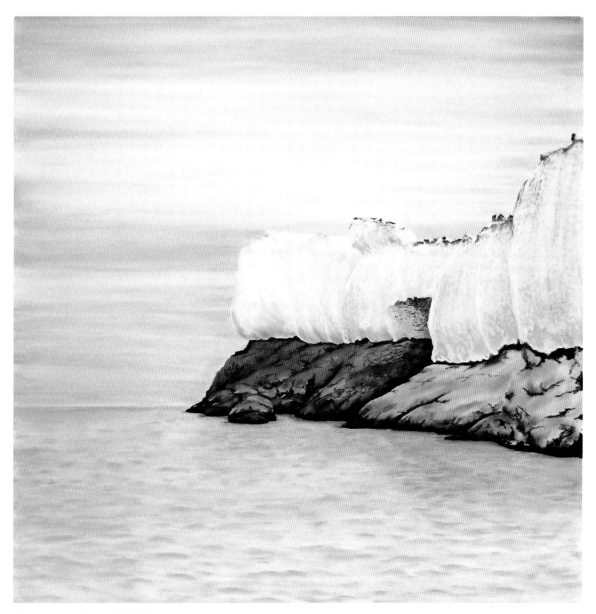

Spring Qannguk, 2012, oil stick

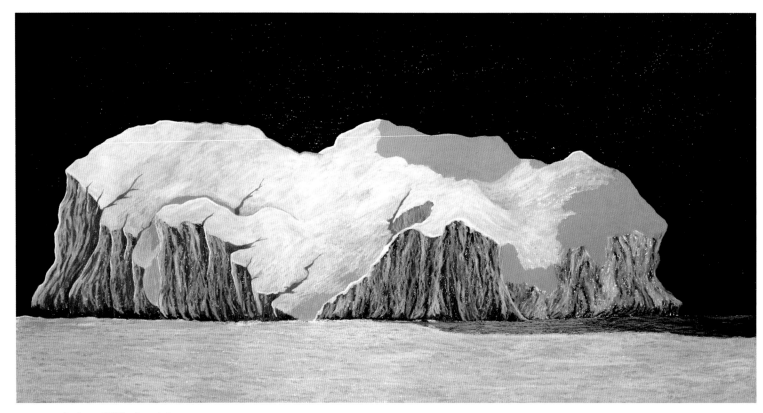

Iceberg, 2016, oil pastel

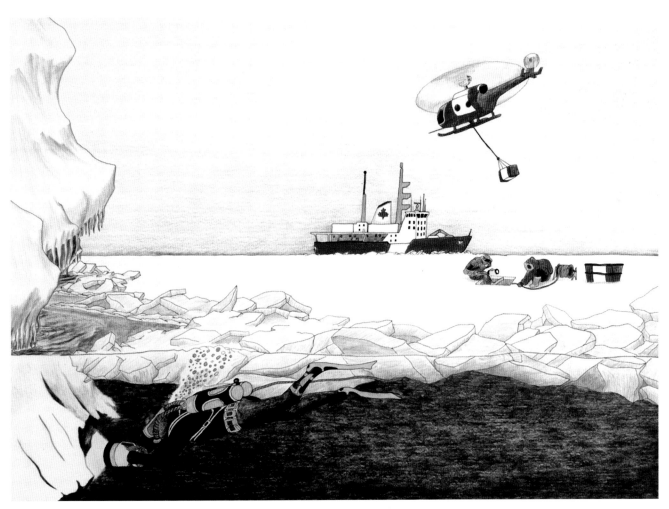

Underwater Research Team, 2007, ink and colored pencil

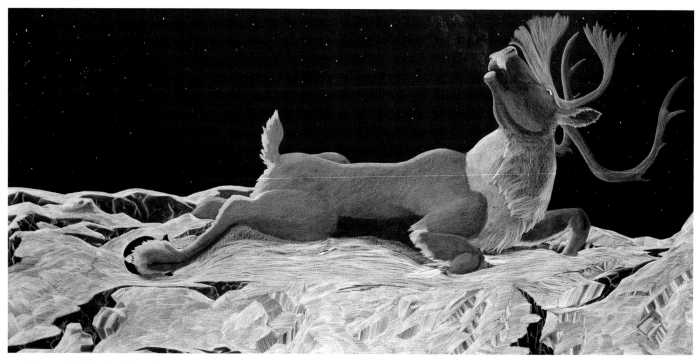

January, 2014, colored pencil

SONG NUMBER 7

My thoughts went constantly,
To the great land my thoughts went constantly.
The game, bull caribou those,
Thinking of them I thought constantly.
My thoughts went constantly,
To the big ice my thoughts went constantly.
The game, bull caribou those,
Thinking of them my thoughts went constantly.
My thoughts went constantly,
To the dance-house my thoughts went constantly.
The dance-songs and the drum,
*Thinking of them my thoughts went constantly.***

LEGACY

In late fall 2016, Tim came down with a virulent infection and flu-like symptoms. His wife, Mary, told me that he continued to push himself, wanting and needing to go out hunting but returning home chilled and shaking. When he finally went to the Cape Dorset Health Centre, he was diagnosed with pneumonia and was prescribed antibiotics. But his condition worsened dramatically over the next few days until he was flown to Iqaluit for hospital treatment, where he died on December 23, 2016, just short of his fiftieth birthday.

News of Tim's death prompted an outpouring of shock, grief, and condolences. His Facebook page overflowed with messages from friends, family, and fans: tributes to him as a devoted and loving father, to his staggering talent, and to his honesty and humor. One of those messages came from Bruce Heyman, then US ambassador to Canada and an admirer and collector of Tim's work. Via Twitter, Heyman shared a video of Tim speaking about his work at Art Toronto. The drawing being discussed is an underwater view of bearded seals, or *udjuk* in Inuktitut. Dangling in the water is Tim's GoPro HERO4, used as a hydrophone to record the songs of the seal. Tim explained that the *udjuk* is the most vocal of seals, and when the ambassador asked what the seals sounded like, Tim whistled an example of the seals' soft, high-pitched conversation. "Awesome," the ambassador replied, "just beautiful."[14] These words are used frequently to describe Tim's work, and Canada lost one of its great ambassadors with Tim's passing. Never before has the North and Inuit life and culture been so vividly portrayed and generously shared.

Tim's July 2017 memorial at Feheley Fine Arts was an occasion for family and friends to come together and pay tribute to the artist and the man. On the wall in the center gallery was a monumental drawing of a bull caribou stuck in the ice and struggling to free himself, his head pitched back and bellowing at the night sky. It is a natural tour de force and one of the most powerful drawings Tim had ever done. Before he died, he designated the proceeds from the sale of the drawing to the Kenojuak Cultural Centre, scheduled to open in Cape Dorset in the summer of 2018.

The late Avrom Isaacs, one of Toronto's most influential contemporary art dealers, used to refer to artists and exhibitions as "making the leap." He never really explained himself, but his meaning was clear. Artists could be technically good or even great and exhibitions could be conceptually or aesthetically interesting but they could still fall flat. Tim knew when he made the leap, and so did his audience. He mastered his subjects, materials, and techniques, always stretching to understand their possibilities. He broke free of the conventions of traditional Inuit art but never lost sight of its essence and history. He imbued his work with his great knowledge and spirit, and through it all, he connected with his audience in a deeply authentic way.

Tim made many references to the spiritual realm in his work. He believed that the souls of his Thule ancestors come back to check on their belongings, and that "the spirit of the caribou will never die and will live with us and within us forever."[15] He wished that the bowhead would live forever, and perhaps they do, "glowing from the spirit of their past."[16] We all wish Tim had lived longer, and we miss the life force that animated him and his time with us. But in the Inuit tradition of *atikulu*, the soul name, his spirit lives on in the children who have been and will be named after him. And, I like to think, with the spirits of his Thule ancestors and the beautiful bowhead swimming in the deep, cold, turquoise waters of the Canadian Arctic.

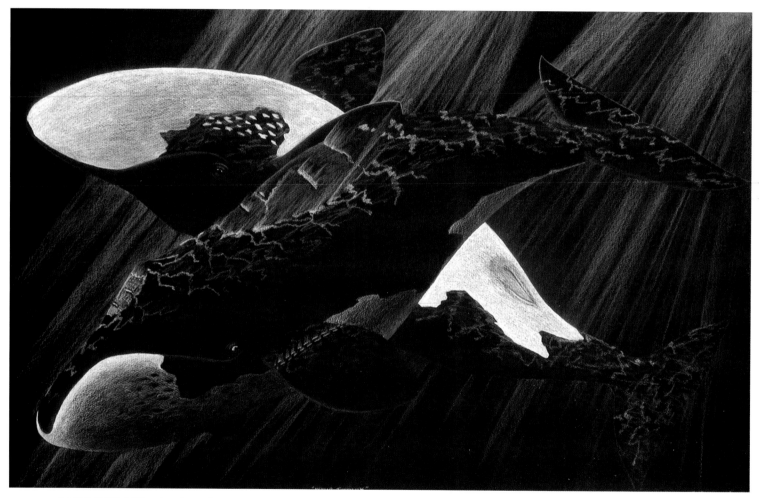

Avviiq Tunnilik, 2011, colored pencil

This is what it might look like with moonlight coming through the water. Bowheads have been around for as long as the Dorset people. They are glowing from the spirit of their past.

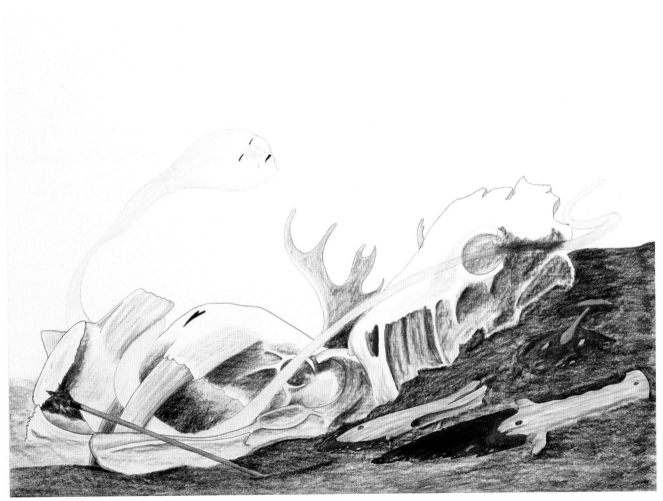

(Untitled) Thule Belongings, 2009, pencil, colored pencil, and ink

[(Untitled) Thule Belongings] is like the soul of the Thule. My thought is that the Thule regularly check on their old belongings.

NOTES

Quotes appearing on plate pages are by Tim Pitsiulak, in conversation with Patricia Feheley. The quotes appear courtesy of Feheley Fine Arts, Toronto, and have been published in Feheley Fine Arts exhibition materials and catalogues.

** Helen Heffron and Diamond Jenness, *Eskimo Songs: Songs of the Copper Eskimos*, vol. 9, *Report of the Canadian Arctic Expedition 1913–18*. (Ottawa, Ontario: The King's Printer, 1925), quoted in Michael P. J. Kennedy, "Inuit Literature in English: A Chronological Survey," *Canadian Journal of Native Studies* 13: no.1 (1993 Annual): 31–41.

1 Tim Pitsiulak, in conversation with Patricia Feheley, June 2009.

2 Tim Pitsiulak, telephone interview by Leslie Boyd, September 16, 2013.

3 Ibid.

4 Shunryu Suzuki, *Zen Mind, Beginner's Mind: Informal Talks on Zen Meditation and Practice* (Boston: Shambhala Publications, 2006), 1.

5 Tim Pitsiulak, telephone interview by Leslie Boyd, September 2013, repeated from conversation with Patricia Feheley, June 2009.

6 Herman Melville, *Moby-Dick; or, The Whale* (New York: Harper & Brothers, 1851), 507, http://mel.hofstra.edu/moby-dick-the-whale-proofs.html.

7 Michael Warren, in conversation with Leslie Boyd, March 31, 2017.

8 Tim Pitsiulak, telephone interview by Leslie Boyd, September 16, 2013.

9 Ibid.

10 Sarah Milroy, "The Hunter Artist," *The Walrus*, https://thewalrus.ca/the-hunter-artist/, July 12, 2012.

11 Ibid.

12 Royal Canadian Mint, "The 100 Year-Old Canadian Arctic Expedition and Life in the North Captured on Two New Royal Canadian Mint Circulation Coins," news release, Ottawa, Ontario, November 22, 2013, https://tinyurl.com /ychztbss.

13 Scott Mullin, in conversation with Leslie Boyd, April 25, 2017.

14 Bruce Heyman, "I want to share with you my conversation with Inuk artist Tim Pitsiulak describing his technique. Glad to have met him." Twitter video, December 23, 2016, 3:19 p.m., https://tinyurl.com/y7uodv9t.

15 Tim Pitsiulak, in conversation with Patricia Feheley, October 15, 2013, published in *Looking Back, Looking Forward* (Toronto: Feheley Fine Arts, 2013).

16 Tim Pitsiulak, in conversation with Patricia Feheley, published in *Drawing Attention: Recent Works by Tim Pitsiulak* (Toronto: Feheley Fine Arts, 2011).

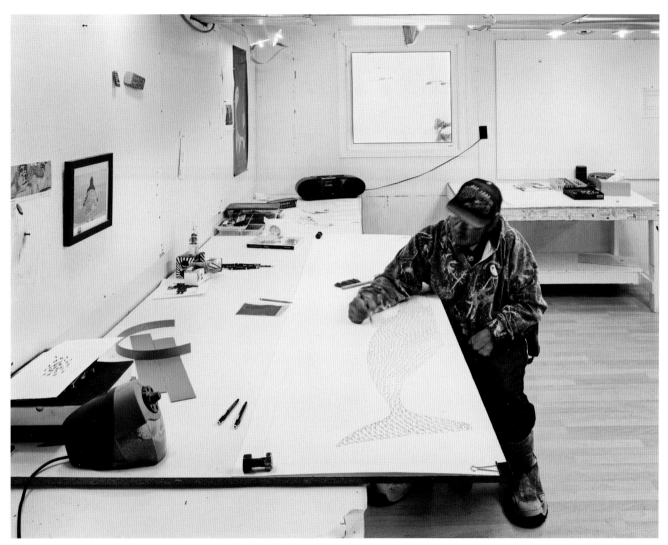

Tim Pitsiulak, Kinngait Studios, Cape Dorset, 2016
Photograph © Joseph Hartman, courtesy of Stephen Bulger Gallery

EXHIBITIONS AND COLLECTIONS

SOLO EXHIBITIONS

Feheley Fine Arts
Toronto, Ontario

2016 *Ice*
 Feheley Fine Arts and Art Toronto

2015 *South Baffin Way*

2013 *Looking Back, Looking Forward*

2011 *Drawing Attention: Recent Works by Tim Pitsiulak*

2009 *Tim Pitsiulak*

Inuit Gallery of Vancouver
Vancouver, British Columbia

2016 *Ningiukulu Teevee and Tim Pitsiulak*

2014 *Recent Drawings by Tim Pitsiulak*

2012 *Tim Pitsiulak: Drawings of Myth and Machine*

Madrona Gallery
Victoria, British Columbia

2015 *Tim Pitsiulak: Land and Life*

SELECTED GROUP EXHIBITIONS

2017–2018 *Kenojuak Ashevak and Tim Pitsiulak: Drawing Life*
 Art Gallery of Hamilton, Hamilton, Ontario

2015 *Northern Narratives*
 McMichael Canadian Art Collection, Kleinburg, Ontario

2014–2015 *Shine a Light: Canadian Biennial 2014*
 National Gallery of Canada, Ottawa, Ontario

2013 *Dorset Seen*
 Carleton University Art Gallery, Ottawa, Ontario

2013 *Sakahàn: International Indigenous Art*
 National Gallery of Canada, Ottawa, Ontario

2013 *Where Do We Come From? What Are We? Where Are
 We Going? Identity in Contemporary Cape Dorset Art*
 McMichael Canadian Art Collection, Kleinburg, Ontario

2011 *Inuit Modern: The Samuel and Esther Sarick Collection*
 Art Gallery of Ontario, Toronto, Ontario

2010 *Cultural Floe: Modern and Inuit Traditions*
 Varley Art Gallery, Markham, Ontario

2010 *Big, Bold and Beautiful: Large-Scale Drawings
 from Cape Dorset*
 Museum of Inuit Art, Toronto, Ontario

2009–2010 *Uuturautiit: Cape Dorset Celebrates 50 Years
 of Printmaking*
 National Gallery of Canada, Ottawa, Ontario

2009 *Arctic Spirit: 50th Anniversary of Cape Dorset's
 Kinngait Studios*
 Art Gallery of Ontario, Toronto, Ontario

2005, 2008, Cape Dorset Annual Print Collection
2009, 2010, 2011, 2013, 2014, 2015, 2016, 2017

COLLECTIONS

Art Gallery of Ontario, Toronto, Ontario
Bank of Montreal
Canada Council Art Bank, Ottawa, Ontario
Cadillac Fairview Group
Global Affairs Canada, Ottawa, Ontario
McMichael Canadian Art Collection, Kleinburg, Ontario
National Gallery of Canada, Ottawa, Ontario
TD Bank Group, Toronto, Ontario
Royal Bank of Canada
Scotiabank

SELECTED PUBLICATIONS AND COMMISSIONS

2013 *Dorset Seen*
 Leslie Boyd and Sandra Dyck, Carleton
 University Art Gallery, Ottawa, Ontario

2013 "Life in the North"
 ¼ oz. fine silver commemorative coin
 commissioned by the Royal Canadian Mint

2012 "The Hunter Artist"
 Sarah Milroy, *The Walrus* magazine, July/August 2012

2010 *Inuit Modern: The Samuel and Esther Sarick Collection*
 Gerald McMaster and Ingo Hessel, Art Gallery of Ontario
 and Douglas & McIntyre, Vancouver, British Columbia

2009 *Uuturautiit: Cape Dorset Celebrates 50 Years
 of Printmaking*
 Leslie Boyd and Christine Lalonde, National
 Gallery of Canada, Ottawa, Ontario

2008 *Guide to Cape Dorset Artists*
 Kyra Vladykov Fisher, Municipality of Cape Dorset,
 Cape Dorset, Nunavut

RESIDENCIES

2016 Open Studio, Toronto, Ontario

2013 New Leaf Editions, Vancouver, British Columbia

2012 Red Deer Museum and Art Gallery, Red Deer, Alberta

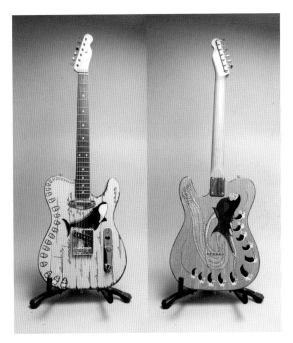

Telecaster guitar, 2013
Acrylic paint on wood
40.6 x 33 x 5.1 cm (16 x 13 x 2 in.)
(body dimensions, not including neck)
Photograph © Feheley Fine Arts

INDEX OF ARTWORKS

ABOUT THE AUTHOR

Leslie Boyd was employed by the West Baffin Eskimo Co-operative for thirty-two years, living in Cape Dorset, Nunavut, and in Toronto, where she was director of the Co-op's marketing division, Dorset Fine Arts. As an independent writer and curator, Boyd has published essays in exhibition catalogues for private galleries and public institutions. She is also editor of *Cape Dorset Prints: A Retrospective*, a comprehensive illustrated history of the Kinngait Studios in Cape Dorset (Pomegranate, 2007). Boyd holds a master's degree in Environmental Studies from York University in Toronto, where she studied the history of the Inuit co-operative movement in northern Canada.